LET'S BE SAFE

Containing Such Useful Information as the
Avoidance of Strangers and Their Candy,
How Not to Be Run Over by a Car, and
How Generally Not to Cut Oneself Open.

Benjamin Darling

CHRONICLE BOOKS
SAN FRANCISCO

Library of Congress Cataloging-in-Publication Data:

Darling, Benjamin, 1966-
 Let's be safe: containing such useful information as the avoidance of
 strangers and their candy, how not to be run over by a car, and how
 generally not to cut oneself open / Benjamin Darling.
 p. cm.
 ISBN 0-8118-0545-X
 1. Children's accidents—Prevention. 2. Safety education. 3. Medicine,
 Preventative. I. Title. II. Title: Let us be safe. HV675.72.D37 1994
 613.6—dc20 93-36103
 CIP
Printed in Hong Kong.

Book and Cover Design: Palomine Design Studio

Distributed in Canada by Raincoast Books, 112 East Third Avenue, Vancouver,
B.C. V5T 1C8

10 9 8 7 6 5 4 3 2 1

Chronicle Books
275 Fifth Street
San Francisco, CA 94103

LET'S BE SAFE

Introduction

The world is surfeited with books. Every possible subject has been covered, explained, and illuminated. Surely, the only remaining gaps in our collective knowledge were filled by those two recently published and wildly successful books: *Cakes Men Like* and *Helpful Hints for Housewives.*

With the aforementioned in mind, I reservedly assented to the agonized pleas of my publisher, begging me to reconsider my early retirement. "You must continue bringing the message to the people," they said. I sighed wearily and bowed to their demands.

But what to write about, I asked myself. It's all been said. A visit to my local Super Book Emporium confirmed these dark suspicions. Everything from aardvark cookery to zygote farming was readily available.

As I left the bookstore, doubts assailed me. I instructed my man to drive on ahead, thinking that a little walk would, perhaps, be inspirational. In any event, I needed to be alone with my thoughts. I shuffled home, my head drooped in the traditional depressed/dejected posture. From this vantage point I spied a half a bagel on a bus bench. My turmoil was making me hungry, so I retrieved it and put quite a bit of it in my mouth. The bagel was a little tough, as bagels sometimes are, and I was trying to rip a hunk off with my teeth when, not noticing that I had wandered out into traffic, I was struck by a car.

My recovery from being hit by the car was fairly swift, eight weeks at most, and in only two of those was I out of the coma and aware of my suffering. It was the bagel that hospitalized me for another three months. My judgment about the bagel's freshness was faulty, and what I perceived as vegetable spread, was not. I had plenty of time to reflect upon my experiences and to "take that next step," as they say in physical therapy parlance.

My lawsuits against bagel and auto manufacturers, city, state, and federal governments were all in vain. I appealed to the local Jewish community on the grounds that they were in some way complicit in my plight, but all to no avail. It would seem that I was alone with my massive medical bills. It became even more important for me to write another book.

One day a visitor came to me at the hospital. I detailed the situation for him—book, accidents, bagels, and all. His voice took on an eerie sing-song tone when he suggested that I might make a book of simple rules for staying alive, the sort of thing one should have learned in grade school if one hadn't had to spend most of one's time in the cloakroom searching for one's galoshes or attempting to glue mirrors to the tips of one's sneakers. Look both ways, don't talk to strangers, that sort of thing. He explained that, while the grand theories of life and death are usually covered in great detail, people have lost sight of some of the simpler rules of self-preservation. In fact, he postulated that we were all in grave danger of dying in a very stupid fashion if we weren't more careful.

His idea didn't seem such a bad one, so I went ahead, took his advice, and created the book you now hold in your hand. I would like to publicly thank the friend who helped me, if ever so slightly, conceive this book, but I can't put a name to the voice, and my blurred vision at the time (nasty side effect of the medication, mostly gone now) prevented me from getting a good look at his person. I fear that someone mistakenly wandered into my room and I was, in fact, conversing with a complete stranger.

—Benjamin Darling

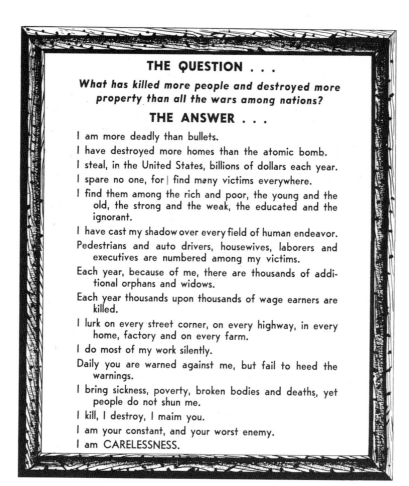

THE QUESTION . . .

What has killed more people and destroyed more property than all the wars among nations?

THE ANSWER . . .

I am more deadly than bullets.

I have destroyed more homes than the atomic bomb.

I steal, in the United States, billions of dollars each year.

I spare no one, for I find many victims everywhere.

I find them among the rich and poor, the young and the old, the strong and the weak, the educated and the ignorant.

I have cast my shadow over every field of human endeavor.

Pedestrians and auto drivers, housewives, laborers and executives are numbered among my victims.

Each year, because of me, there are thousands of additional orphans and widows.

Each year thousands upon thousands of wage earners are killed.

I lurk on every street corner, on every highway, in every home, factory and on every farm.

I do most of my work silently.

Daily you are warned against me, but fail to heed the warnings.

I bring sickness, poverty, broken bodies and deaths, yet people do not shun me.

I kill, I destroy, I maim you.

I am your constant, and your worst enemy.

I am CARELESSNESS.

Contents

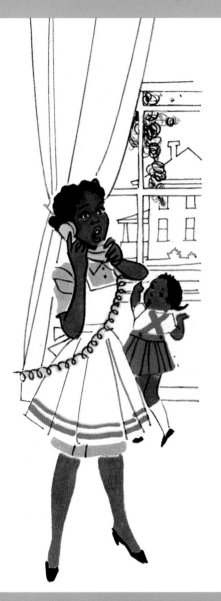

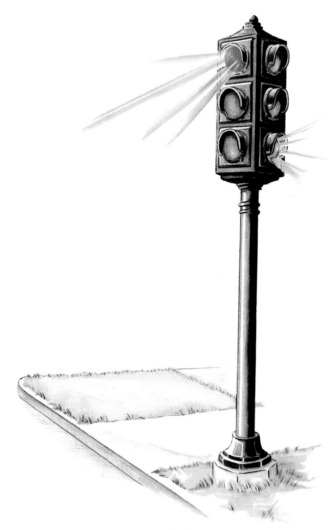

Safety

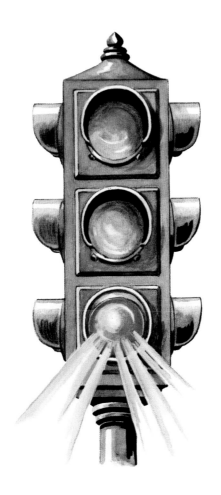

It is green.
It tells us to go.

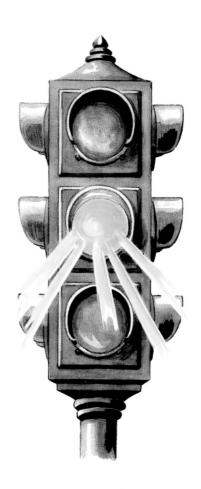

It is yellow.
It tells us to wait.

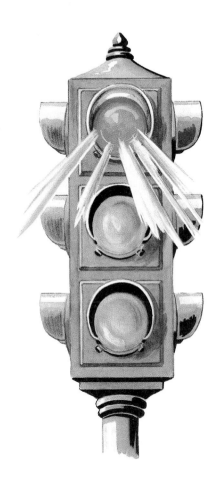

It is red.
It tells us to stop.

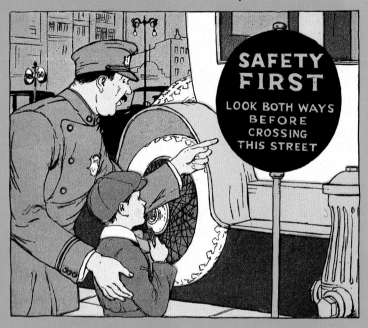

Look both ways before crossing the street.

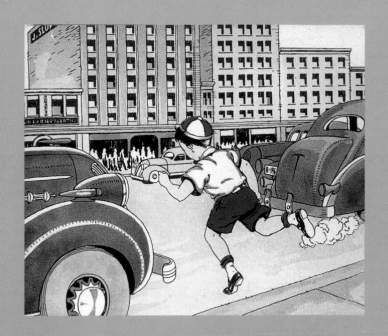

Running out into the street
from behind a parked car is dangerous.

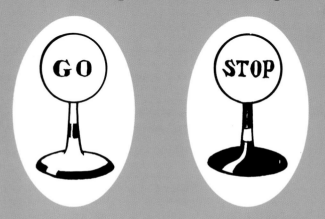

Don't drop banana peels in the street.

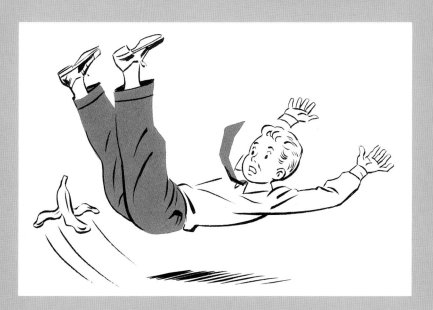

Someone might slip and fall.

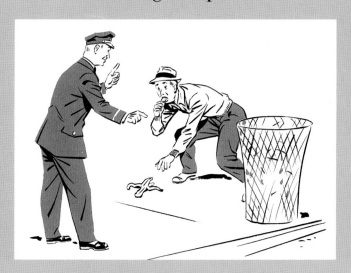

Who Gets Hurt on the Tracks?

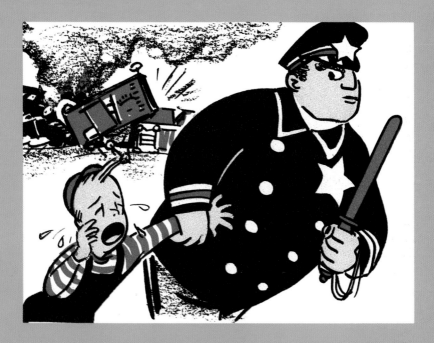

Most children would not willingly hurt anyone. But some children think it is fun to play on the railroad tracks. Often they do something that could cause an accident. They do not mean harm, of course. They just want to see what would happen.

Afterwards, some of these children cry and scream. "Please don't take me away," they plead with the F.B.I. man or the policeman who comes to arrest them. "I didn't mean any harm. I only wanted to see what would happen."

But then it is too late to be sorry. Often, the damage has been done. Perhaps innocent people have been hurt and killed.

Some of these children, who did not mean to do any harm, really kill more innocent people and destroy more property than the sneaks and criminals who do it on purpose.

That is why the railroads want people to stay off railroad property. It is to keep people, especially children, from getting hurt. And it is to protect the lives of innocent people riding on their trains.

That is why it is against the law to go on the tracks. Did you know you could be arrested for walking on a railroad track? Yes, that is true. Of course, the railroads do not want to have to put you in jail. Instead they ask you, "Please stay off our tracks. It is dangerous for you. It is dangerous for our passengers. It is dangerous for everybody. Please stay off the railroad tracks."

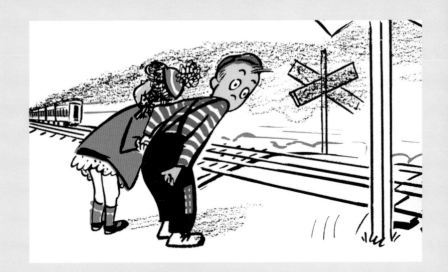

Railroad tracks belong to the railroad. It is against the law to trespass on them.

Railroad tracks are dangerous for boys and girls. Many boys and girls who play on them get badly hurt.

It is a crime to put things on a track or throw stones at trains or signals.

Always be careful when crossing the tracks at a public crossing. Help others to cross safely.

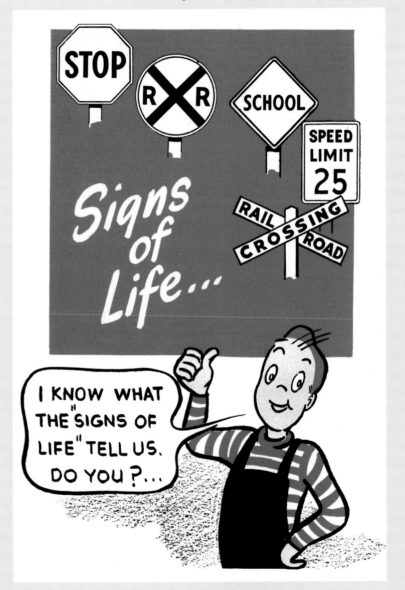

The "Don'ts" of Bicycling

- Do not ride two or more on a bicycle.

- Do not swerve from side to side.

- Do not hitch on vehicles of any kind.

- Do not leave curb without looking.

- Do not ride on icy pavements, during snow storms or heavy rains—it's too great a risk.

- Do not make turns in the middle of the block.

- Do not ride at night without lights.

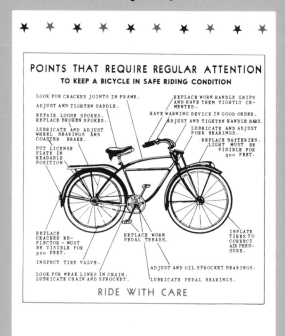

POINTS THAT REQUIRE REGULAR ATTENTION
TO KEEP A BICYCLE IN SAFE RIDING CONDITION

LOOK FOR CRACKED JOINTS IN FRAME.

ADJUST AND TIGHTEN SADDLE.

REPAIR LOOSE SPOKES. REPLACE BROKEN SPOKES.

LUBRICATE AND ADJUST WHEEL BEARINGS AND COASTER BRAKE.

PUT LICENSE PLATE IN READABLE POSITION

REPLACE WORN HANDLE GRIPS AND HAVE THEM TIGHTLY CEMENTED.

HAVE WARNING DEVICE IN GOOD ORDER.

ADJUST AND TIGHTEN HANDLE BARS.

LUBRICATE AND ADJUST FORK BEARINGS.

REPLACE BATTERIES. LIGHT MUST BE VISIBLE FOR 500 FEET.

REPLACE CRACKED REFLECTOR—MUST BE VISIBLE FOR 500 FEET.

INSPECT TIRE VALVE.

LOOK FOR WEAK LINKS IN CHAIN. LUBRICATE CHAIN AND SPROCKET.

REPLACE WORN PEDAL TREADS.

INFLATE TIRES TO CORRECT AIR PRESSURE.

ADJUST AND OIL SPROCKET BEARINGS.

LUBRICATE PEDAL BEARINGS.

RIDE WITH CARE

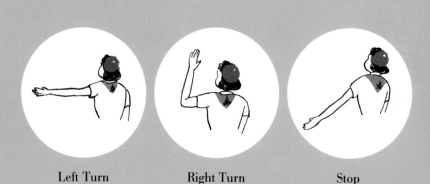

Left Turn Right Turn Stop

A BICYCLE IS A VEHICLE AND A MEANS OF TRANSPORTATION
FOLLOWING RULES OF SAFE RIDING SHOULD BE OBSERVED

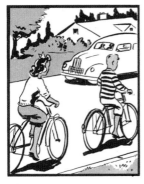

Ride your bicycle in single file in a straight line near the curb.

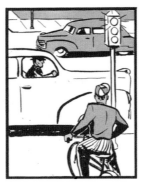

Obey Traffic Signals.

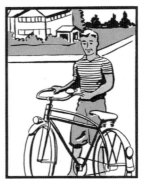

Have head light, tail light and sounding device.

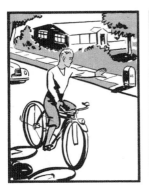

Signal and look around when leaving curb or making turn.

Keep your head up—alert at all times.

Keep your speed down—and rigid hold of your handlebars.

FOLLOWING THESE RULES MAY SAVE YOUR LIFE

Copyright — BICYCLE SAFETY GUIDE. Prepared and Paid for by POLICE & SHERIFFS' SAFETY
COUNCIL, 3820 W. Wisconsin Ave., Milwaukee 8, Wis.

DRIVEWAY—ENTERING PUBLIC HIGHWAY

Pedaling away for some fun.

Talking and looking at each other.

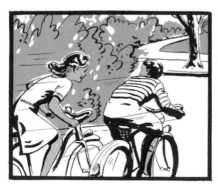

Plenty of speed — no thought of danger.

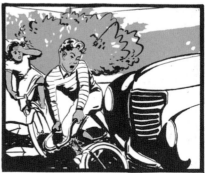

The oncoming car doesn't have a chance to apply brakes — striking bicyclist headon.

Stop before entering street — A precious moment in looking before you enter may save your life.

KEEP YOUR MIND ON BICYCLING WHEN RIDING

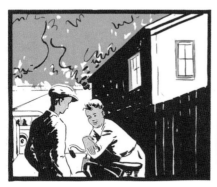

Ed—Swell day for a game of ball.
Al—Sure is! Duck home and get your ball and glove.

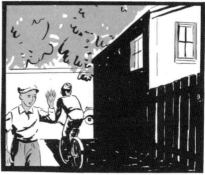

Ed starts down the alley—mind all set on that ball game.

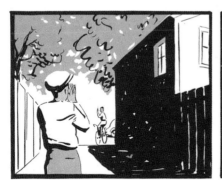

Al—Hey Ed, bring your bat. too. Ed turns his head and yells, Okay!

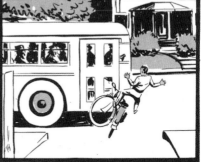

But entering the street Ed pumps headon into a street transportation bus. Sad but true — another healthy boy meets his death.

When entering street from an alley — bear in mind that the vehicle on the street has the right-of-way.

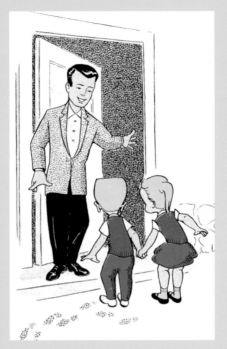

A person may invite you to a house, garage or shed.
Say "No!" to him and run and tell your Mother what he said.

Dorene and Dan, The Cautious Twins, run home as good kids do.
For home's the very safest place when danger threatens you.

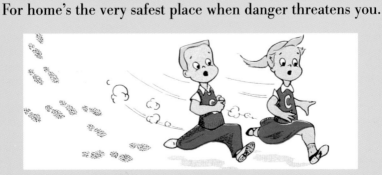

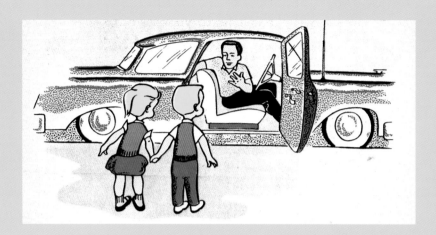

If someone in a motor car
should offer you a ride,
scream loudly as you run away
but do not get inside.

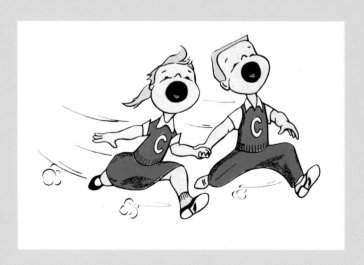

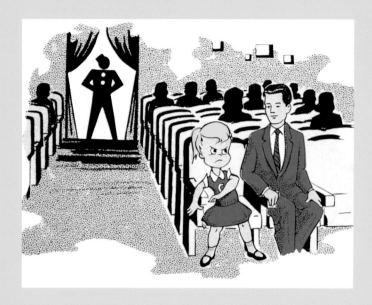

And when you go to see a show, if someone touches you,
get up and move away from there and tell the usher too.

Don't let a stranger pat your hand or straighten up your clothes;
good strangers let a child alone, as everybody knows.

Most people love a little child; some grown ups, though, are bad.
The bad ones look like good ones, like any Mom or Dad.

So that is why you must not talk to strangers that you meet;
don't let them give you any toys, or anything to eat.

If someone that you do not know should offer you a treat,
remember how he looks and talks, but run fast up the street.

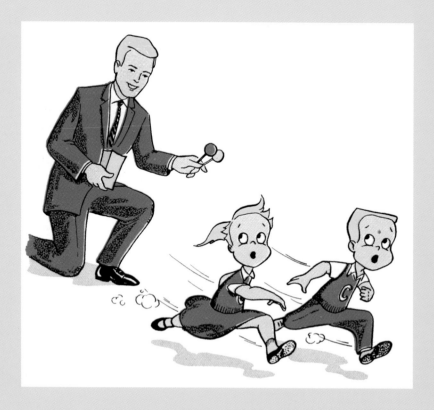

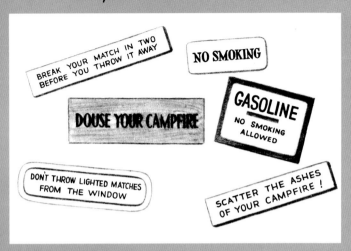

BREAK YOUR MATCH IN TWO
BEFORE YOU THROW IT AWAY

NO SMOKING

DOUSE YOUR CAMPFIRE

GASOLINE
NO SMOKING
ALLOWED

DON'T THROW LIGHTED MATCHES
FROM THE WINDOW

SCATTER THE ASHES
OF YOUR CAMPFIRE !

Poison ivy

Sumac

Poison oak

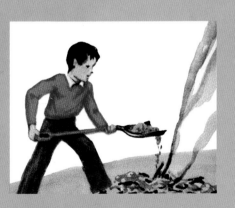

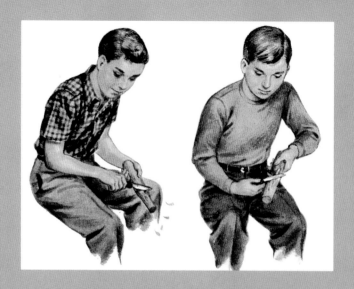

Be careful with sharp knives or razor blades.
Always whittle away from you.
See that cuts have prompt attention.

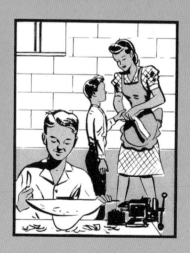

Swimming and Skating Safety

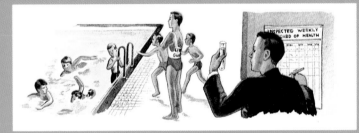

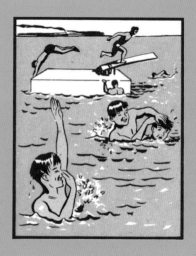

- Don't swim at beaches unless there is a life guard on duty.

- Going into water after eating may cause cramps.

- Don't swim in water that is too cold, and don't duck playmates in deep water.

- Always stay within safe distance of shore.

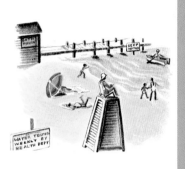

Use a plank to rescue a person who has
fallen through the ice.

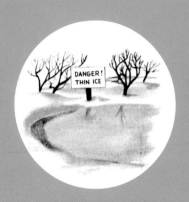

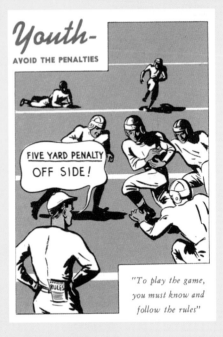

Every game played by human beings, young or old, is governed by rules. Most games require officials (umpires, referees, judges, etc.) to determine whether any players have, intentionally or unintentionally, broken one or more rules, and if so to determine and impose a penalty.

In the Game of Life everything we do, every action we take, is determined by the rules society has set up, and which are known to you and me as "The Law."

No team, no individual, can long violate the rules and win a championship—IT CAN'T BE DONE. Violate the rules of the athletic contest and you and the team are penalized. Violate the rules in the Game of Life and you, your relatives, and your friends, and every other member of society lose.

Don't neglect blisters, which might cause infection. (President Coolidge's son died from infection from a blister.)

Don't play in the streets. Always wear a safe mask and, if possible, a chest protector when catching behind a bat.

Please stay seated

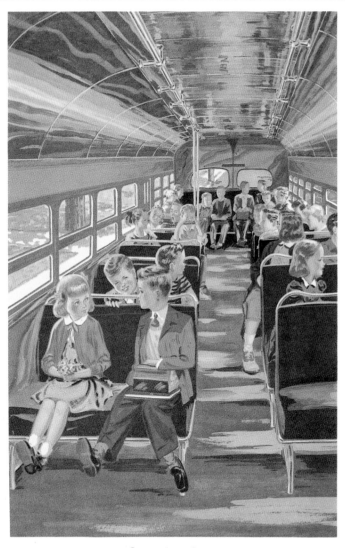

On the bus

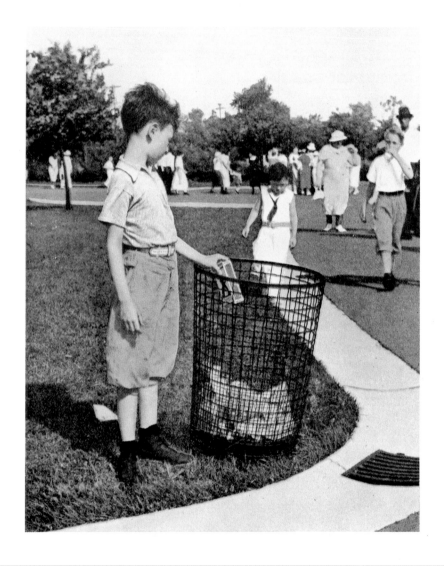

In the Library

Do not talk out loud in the library.
Be careful of the books.
Turn the pages slowly.
Do not tear the pages.

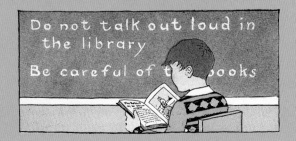

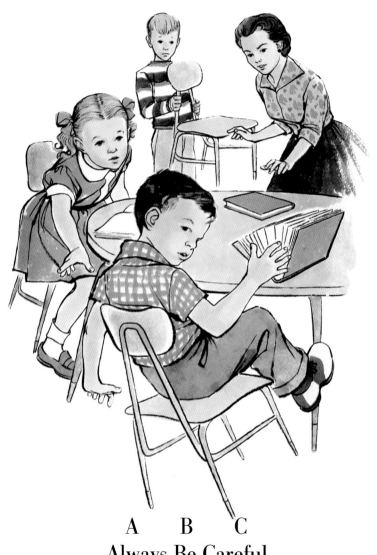

A B C

Always Be Careful.

Do not play with matches.

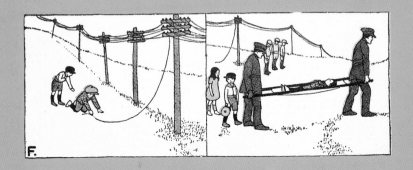

Do not touch loose wires.

Don't ever touch any kind of electric appliance
with damp hands.

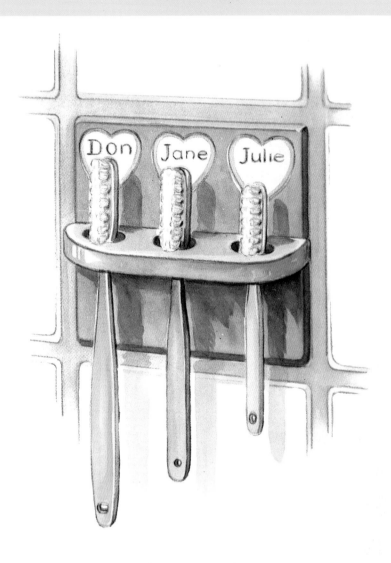

Good Teeth

Every boy and girl must have a toothbrush.
They must brush their teeth every day.

The Story of Tommy Tooth

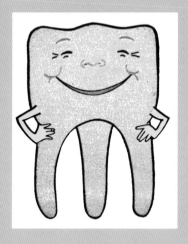

If you'll listen well, a story I'll tell
About your good friend, Tommy Tooth.
When you grow old,
 you'll be glad I've told
This tale that is founded on truth.

Tommy Tooth will smile
 and laugh all the while
If you brush him "good" each day.
Every morning and night,
 if you do it just right,
He will always be happy and gay.

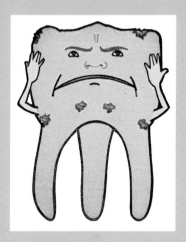

If you're not good
 and don't clean as you should
Tommy Tooth each night and morn,
His face turns gray
 and his smile fades away
Because he's so sad and forlorn.

He will feel so bad
and look so sad—
If he could speak, to you he'd say,
"Something—oh, see!—
 digging holes in me!
Please come and take it away."

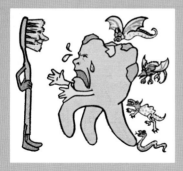

When bad germs chase
 all over his face,
And many more come with a rush,
Tommy Tooth holds out
 his arms with a shout,
"Help, help! Oh, Friend Tooth Brush!"

Tommy Tooth knows,
 wherever he goes,
If Tooth Brush by his side will stay,
He will always feel fine,
 and germs won't dare dine,
For Tooth Brush will sweep
 them away.

Happy as can be,
smiling bright with glee,
Mr. Tooth is white as snow.
Hand in hand, he takes his stand,
With friends who like him so.

Do you put dirty fingers into your mouth?

Pencils may have dirt on them.

Keep fingers and pencils
out of your mouth.

We should always wash our hands and
faces before eating.

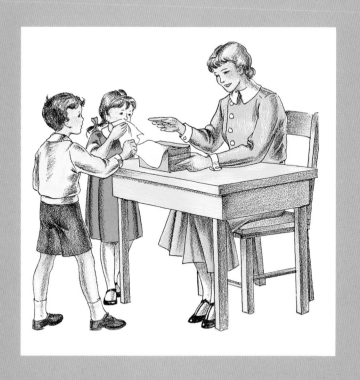

Be careful not to broadcast any germs!

I'll cover my face when I
cough or *sneeze*,
Or when I must *yawn* —
so that no one sees.

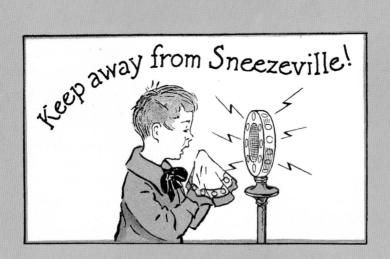

Keep away from Sneezeville!

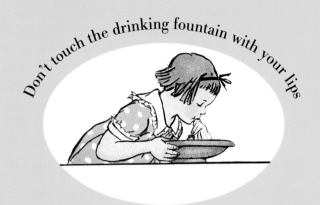

Don't touch the drinking fountain with your lips

FOOD YOU SHOULD NOT EAT

Food picked up from floor or street
Is not clean food for you to eat.
And dirty food you must not touch,
Though you may want it very much.

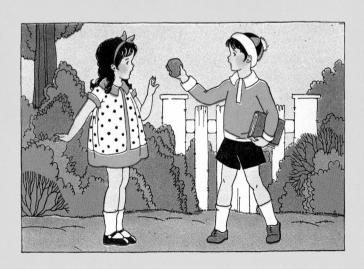

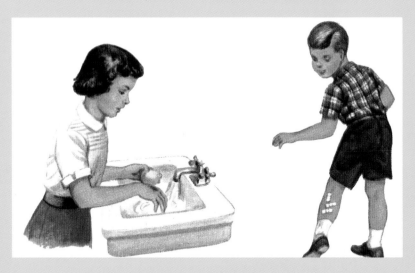

1. Wash the cut with warm water and soap.
2. Have someone put iodine on the cut.
3. Put a clean bandage over the cut to keep out all dirt.
4. Put a piece of tape over the bandage to hold it in place.

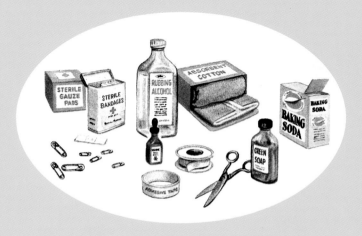

The happy children are the ones who think
Of being safe and healthy, all day long.
They know that doctors and police are friends
Who want them to be joyful, well, and strong.